SIX FAIRY TALES

FROM THE BROTHERS GRIMM
WITH ILLUSTRATIONS BY

DAVID HOCKNEY

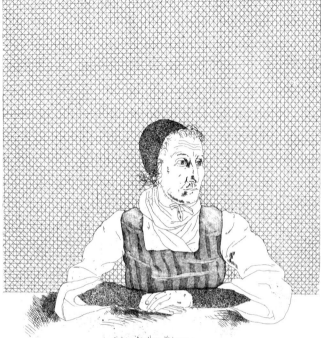

Catherina Dorothea Viehmann

Märchen frau

4/13

10 OCT 2014

W/D

SIX FAIRY TALES

FROM THE BROTHERS GRIMM
WITH ILLUSTRATIONS BY

DAVID HOCKNEY

Royal Academy of Arts

PUBLISHER'S NOTE
The first edition of this book was published in April 1970
by the Petersburg Press, London, in association with the Kasmin Gallery.
The etchings were drawn onto plates by the artist,
proofed by Maurice Payne and printed by Piet Clement.
The text was translated from the German original by Heiner Bastian.

ROYAL ACADEMY PUBLICATIONS
Beatrice Gullström
Elizabeth Horne
Carola Krueger
Sophie Oliver
Peter Sawbridge
Nick Tite

Design: Kathrin Jacobsen
Colour origination: DawkinsColour

Typeset in DTL Unico
Printed in Italy by Graphicom

London Borough
of Southwark

D

SK 2325519 6

Askews & Holts | 26-Mar-2013

398.2 ART | £16.95

British Library Cataloguing-in-Publication Data
A catalogue record for this book is available
from the British Library
ISBN 978-1-907533-24-2

Distributed outside the United States and Canada
by Thames & Hudson Ltd, London

Distributed in the United States and Canada
by Harry N. Abrams, Inc., New York

CONTENTS

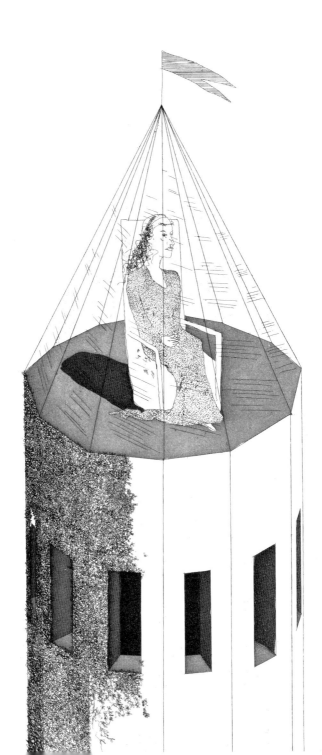

THE LITTLE SEA HARE

A Princess lived in a castle in a large room high up under the battlements. She could see her whole kingdom from twelve windows, one in each wall of the room. From the first she could see more clearly than other people; from the second even better; and from each window still more, until from the twelfth she saw everything above and below the earth. The Princess knew everybody's secrets.

She was very proud; and since she wished to rule alone it was proclaimed that she would marry only the boy who could hide so well that it would be impossible for her to see him. Anyone who tried to hide and failed would have his head cut off and stuck on a post.

Ninety-seven skulls displayed in front of the castle had frightened the young men away, and for many years no one had dared to take up her challenge. The Princess was happy and thought: 'I shall always be free.' Then three brothers came to try their luck. The eldest hid himself carefully in a lime pit, but the Princess saw him from the first window and had his head cut off. The second hid in the cellar of the castle, but again she only had to look through the first window, and shortly after his head was nailed to the ninety-ninth post. So the youngest brother asked the Princess to let him have a day to work out a plan and he pleaded also for three chances. 'If you

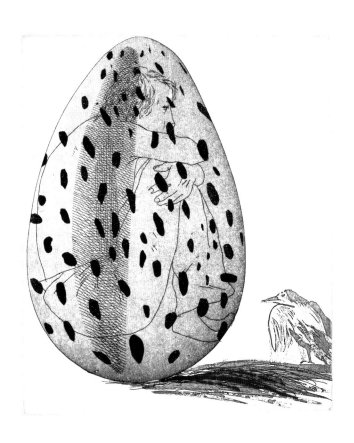

found me the third time, I wouldn't want to live anyway.'
He was very handsome, and taken by his looks, she
agreed: 'I'll let you have three chances, but I'm quite
sure you won't succeed.'

For a whole day the boy tried to think of a hiding
place, but his mind was blank; so he took his gun and
went off to the forest to hunt. When he saw a raven
perched in a tree he raised his gun to fire: 'Don't shoot,'
cried the raven, 'don't shoot, I'll make it worth your
while'; so the boy lowered his gun and walked on.
Soon he came to a lake where he surprised a big fish
lying near the bank. As he took aim, the fish cried out
in alarm: 'Don't shoot, I'll make it worth your while';
so the boy watched him swim away and walked on.
Later he met a limping fox at which he fired but missed:
'Come over here', cried the fox, 'and pull this thorn out
of my foot.' The boy did as he was asked, but still he
planned to kill and skin him. 'Don't,' the fox pleaded,
'don't do it, I'll make it worth your while'; so the boy
let him go, and as it was evening he returned home.

He had to hide from the Princess the next day,
but he couldn't think where, so as soon as it was light he
went into the forest to look for the raven. When he found
him, the boy said: 'I let you live, now tell me where I can
hide so the Princess won't find me.' The raven lowered
his head and thought about it for a while. 'I've got it!'
he croaked. He took an egg out of his nest, cut it in half,
put the boy into it, closed it up and sat on top. When

the Princess looked through the first window, she couldn't see the boy; she tried the second, the third, and all the others until from the eleventh window she saw him. The raven was shot and when the egg was broken open the boy had to face her. 'I won't kill you this time,' she warned him, 'but if you can't do any better than that, you're finished.'

Next morning the boy went to the lake and called to the fish: 'I let you live, now tell me where I can hide so the Princess can't see me.' The fish thought about it for a long time. At last he cried: 'I've got it, I'll hide you in my belly.' So he swallowed the boy and dived to the bottom of the lake. The Princess looked through her windows, but when she couldn't see him even from the eleventh she was terrified; then from the last window she spotted him. The fish was caught and killed; and you can imagine how the boy felt when its belly was slit open. The Princess smiled as he lay on the ground gasping for breath; 'I won't kill you yet, but I'm quite sure that by tomorrow evening your head will be up there on the hundredth post.'

On the last day, downcast and walking in a field, he met the fox. 'You know every hole around here,' he said. 'I let you live, now tell me where I can hide so the Princess won't see me.' 'That's not so easy,' the fox answered with a worried look, 'let me think.' Then he chuckled: 'I've got it!' He took the boy to a spring and they both jumped in. They came out together as a pedlar and a little sea hare. When the pedlar showed the pretty animal in the market

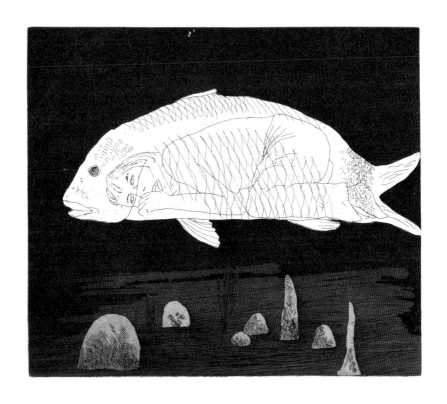

place, such a crowd gathered around them that the Princess sent a servant to find out what was going on. When she saw the little sea hare she liked it and bought it for herself; but as the pedlar handed him over he whispered: 'When the Princess looks through her windows, crawl under her hair.'

It was now time to look for the boy. The Princess ran from window to window searching for him, and when she couldn't see him even from the twelfth window she lost her temper; she slammed it down so hard that the glass in it and all the others broke into a thousand pieces, and the castle shook to its foundations.

Suddenly the Princess felt the little creature behind her ear. She grabbed at it, and threw it to the floor screaming: 'Get out of here; be off with you.' Then the little sea hare ran to the pedlar and they both rushed to the spring and dived in. As they parted, the boy thanked the fox: 'Compared to you, the raven and the fish were very stupid. You know all the tricks.'

The Princess accepted her fate. After the wedding the boy became ruler of the entire kingdom, but he never told her where he had hidden the third time or who had helped him. She admired him and thought to herself: 'He is cleverer than I am.'

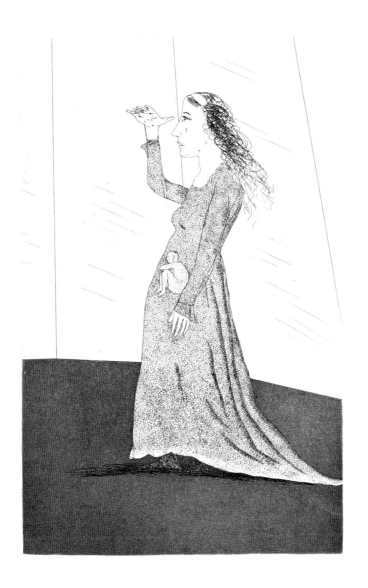

FUNDEVOGEL

A forester was out hunting in the woods one day when suddenly he heard the sound of crying. He followed the noise until he came to a clearing where he saw a child high up on a branch of a great tree; for a giant bird had snatched it from its mother's arms as she slept. He climbed up to get the child, thinking: 'I'll take it home and raise it with my little Liz'; and since it was a bird that had stolen the little boy he named him Fundevogel.

The two children grew up together; they loved each other so much that one was sad when the other was away.

The forester had an old cook. One evening she went out with two buckets to fetch water; after she had done this several times, little Liz became curious and asked her: 'Old Sanne, what is all this water for?' 'If you can keep a secret,' the cook whispered, 'I'll tell you!' When Liz promised, she told her: 'Tomorrow morning when your father is out hunting I'll heat up this water, and when it's boiling in the pot I'll throw in Fundevogel and cook him.'

Very early the next morning, as the forester left to hunt, Liz woke Fundevogel and said: 'If you'll never leave me, I'll never leave you'; and Fundevogel answered: 'Not now nor ever.' 'Then I'll tell you why Old Sanne brought in so many buckets of water last night. I was curious and asked her what she was going to do; she told me she would

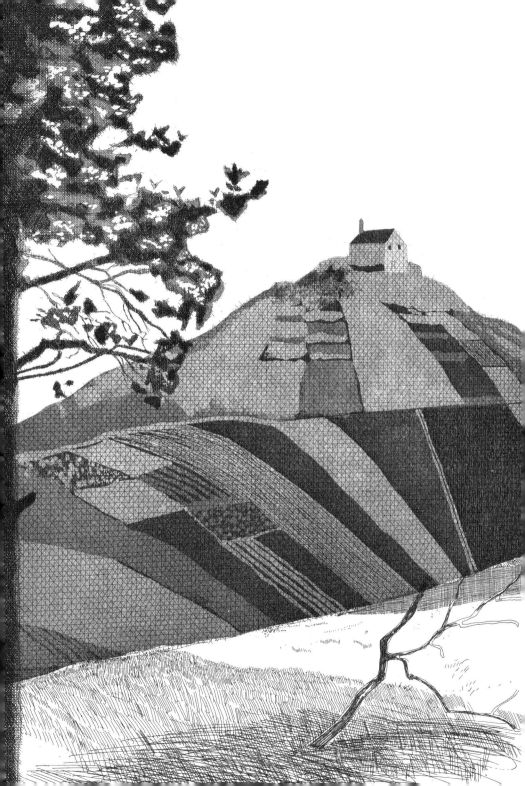

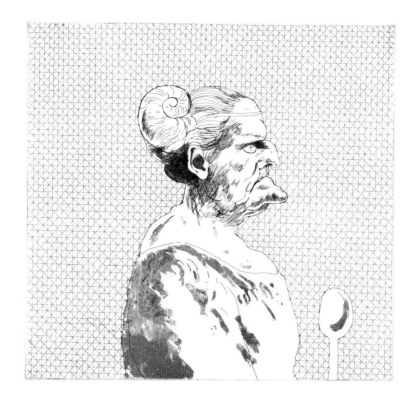

wait until father had gone out hunting then boil the water and throw you in. Hurry now, let's get dressed and escape.' So the children got up quickly and left the house.

As soon as the water was boiling in the pot the cook went into the bedroom to grab Fundevogel, but both beds were empty. She was terribly worried now and thought to herself: 'What can I say to the forester when he comes home and sees the children are gone? I must get them back quickly!'

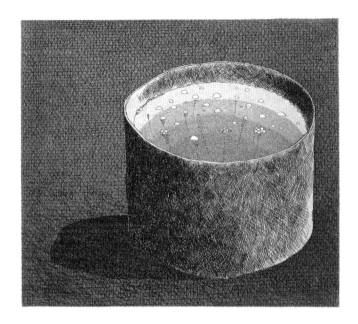

The cook sent three servants off on the run to catch up with the children. They were sitting at the edge of the forest when they saw the servants coming, and Liz said to Fundevogel: 'If you'll never leave me, I'll never leave you'; and Fundevogel answered: 'Not now nor ever.' So Liz begged him, 'Turn into a rosebush, and I'll be a rose.' When the three servants reached the edge of the forest, they saw nothing but a rosebush with a single rose. 'Nobody here,' they called to each other, and told the old

17

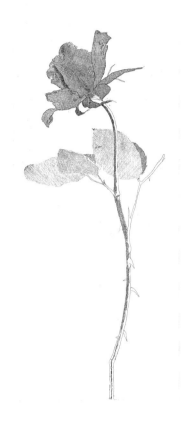

cook: 'We couldn't find the children; we saw nothing
but a rosebush with a single rose.'

The cook was angry. 'You fools!' she shouted. 'Why
didn't you split the rosebush in two, break off the rose and
bring it back with you? Quick, go back at once and do it!'
So they ran back to look for the spot. But the children saw
them coming and Liz said to Fundevogel: 'If you'll never
leave me, I'll never leave you'; and Fundevogel answered:

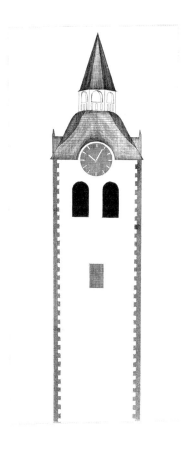

'Not now nor ever.' So Liz begged him, 'Turn into a tower and I'll be its clock'; and as the three servants came near they saw only a tower with a clock near the top. 'We can do nothing here, let's go home.' When they got back the cook asked them if they had found anything. 'No, we saw nothing but a tower with a clock near the top.' 'Oh, you fools,' she screamed, 'why didn't you tear down the tower and bring back the clock?'

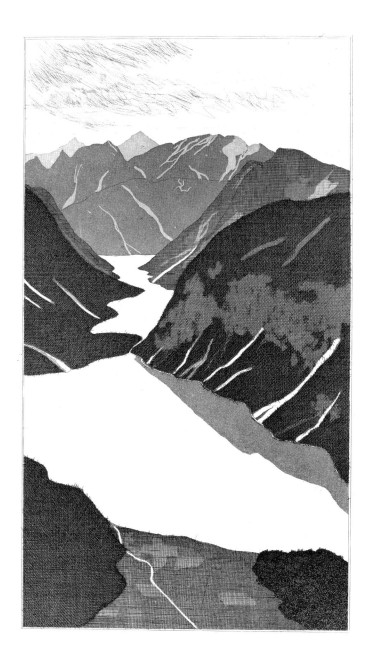

This time she went with them herself to catch the children; but they saw the servants coming from a distance, with the old cook waddling behind. Liz said to Fundevogel: 'If you'll never leave me, I'll never leave you'; and Fundevogel answered: 'Not now nor ever.' So Liz begged him: 'Turn into a lake, and I'll be a duck swimming on it.' When the cook saw the lake she lay down on her belly and started to drink it dry. Quickly, the duck swam over, grabbed her nose in its beak and pulled her into the water. The old cook drowned; and the children were home before the forester came back from the woods.

RAPUNZEL

A man and a woman had long wanted a child, and
they believed that at last their wish would come true.
The house in which they lived had a small window at
the back which looked out on a wonderful garden with
lovely flowers and herbs. But it was surrounded by
a high wall, and nobody dared go in for it belonged
to a powerful Enchantress.

One day the woman was standing at the window
looking into the garden when she noticed a flower bed.
Planted with the most luscious rapunzels, it looked
so fresh and green that she couldn't leave the window.
'I must have some,' she thought, but since she knew it
was forbidden, she grew pale and miserable. Her husband
was worried and asked: 'What's wrong with you?' 'Oh,
I saw some wonderful rapunzels in the garden behind
the house, and if I can't have some I shall die.' The man
loved his wife and wanted to help: 'I can't let her die,'
he thought, 'I must get her some rapunzels whatever
the cost.'

As it grew dark he sneaked into the garden, snatched
a handful of the plants and took them to his wife, who
quickly made herself a salad. It was so delicious that
the next day she longed for more; and to calm her, her
husband climbed into the garden once again. He was

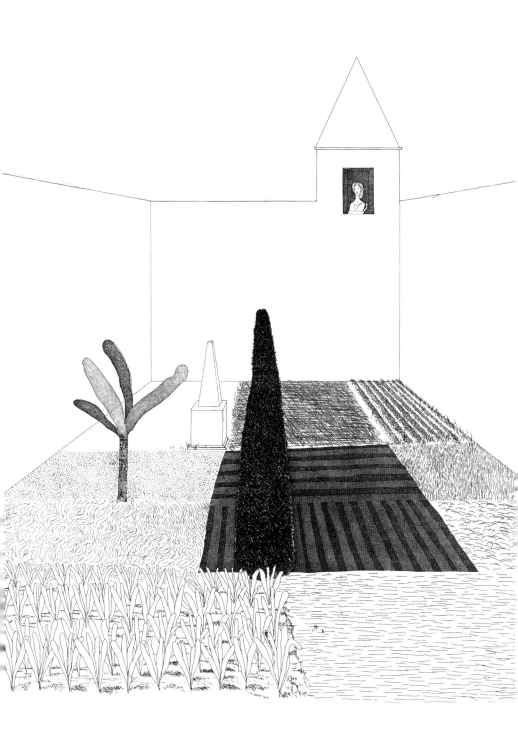

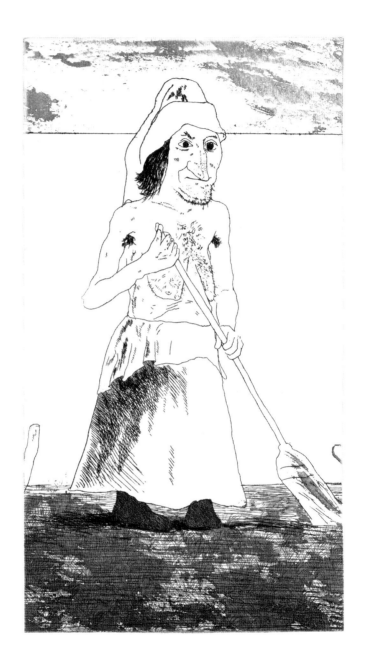

24

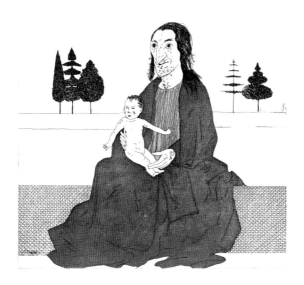

given a terrible fright when the Enchantress crept up
behind him. 'How dare you,' she cried out in a rage, 'how
dare you climb into my garden and steal my rapunzels?'
'I know I've done wrong,' he pleaded, 'but pity me. I was
forced to do it; my wife saw your rapunzels from the
window and she wanted them so much that she certainly
would have died if I hadn't stolen her a few.' The
Enchantress was cunning: 'If that's the truth,' she replied,
'I'll let you take all the rapunzels you want. But there is one

25

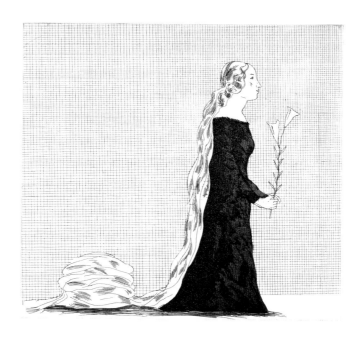

condition; you must give me your child as soon as it is born.
It will have a good life and I'll care for it like a mother.'
In his terror the man agreed, and when the child was born
the Enchantress took it away and named it Rapunzel.

Rapunzel was the most beautiful girl under the
sun. When she was twelve years old the Enchantress
led her deep into the forest and locked her up in a small
room high up in a tower, which had neither doors not
steps but only one window at the very top. When

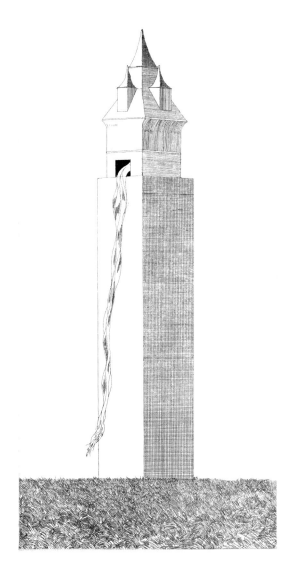

the Enchantress wanted to enter she stood under the
window and called:

Rapunzel, Rapunzel
Let down your hair.

Rapunzel had long blond hair. When she heard the
Enchantress calling she would wind it round a window-
hook and let it down to the ground, so the old woman
could climb up.

A few years later a Prince was riding through the
forest and, as he passed by the tower, he heard a beautiful
voice and stopped to listen: Rapunzel was singing. The
Prince longed to see her and searhed for a door but the
tower had none. He couldn't forget her voice and came
to listen every day. Then one afternoon he heard the
Enchantress calling:

Rapunzel, Rapunzel
Let down your hair.

Rapunzel let down her hair and the Enchantress climbed
up. 'Oh! If that's the ladder,' he thought, 'then I can climb
up as well.' And when it was dark he went to the tower
and called:

Rapunzel, Rapunzel
Let down your hair.

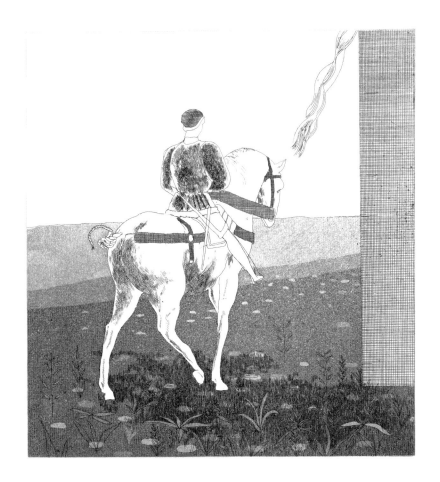

Her hair fell down and he climbed up. Rapunzel was very frightened for she had never seen a man; but the Prince was kind and told her how the song had moved him. When Rapunzel saw how young and handsome he was, she thought: 'He will love me better than the old woman.' She put her hands in his and said: 'I wish I could go with you, but I can't get out. Each time you come bring a roll of silk and I will weave a ladder. When it's finished we'll escape together on your horse.' And to keep out of the old woman's way they agreed he should come only at night.

The Enchantress didn't suspect anything until one day Rapunzel said to her: 'Tell me, why are you so much harder to lift up than the young Prince who comes every night?' 'What's that you're saying? You horrid girl!' the old woman screamed. 'I thought I had hidden you from everyone; but you have cheated me!' She was so angry that she grabbed Rapunzel's hair and cut it off with a pair of scissors; the lovely blond hair fell to the floor. Then the cruel Enchantress carried the girl off to an endless desert and left her to look after herself.

The day she cast out Rapunzel the old woman fastened the long blond hair to the window-hook. When the Prince came and called:

Rapunzel, Rapunzel
Let down your hair,

she let it down and he climbed up; but instead of Rapunzel he found the Enchantress. 'The bird has flown,' she sneered, 'the cat has got it and will scratch out your eyes as well. Forget Rapunzel, you will never see her again.' In his sorrow the Prince threw himself from the window. He wasn't killed, but his eyes were pierced by thorns, and blinded, he staggered away. Roaming through the forest, helpless and in great pain, he ate nothing but roots and berries, and wept and mourned the loss of his lovely Rapunzel.

Years later he reached the desert where Rapunzel lived sadly with the twins she had borne. When at last she saw him coming she called his name and he knew it was her voice; and as they embraced and wept, two of her tears fell on his eyes and he saw again. So he took her with the children to his kingdom, where they lived happily for many years.

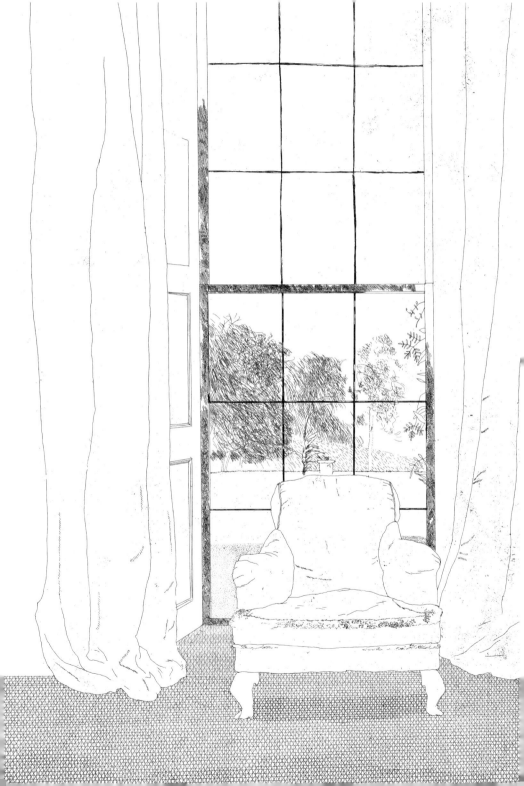

THE BOY WHO LEFT HOME
TO LEARN FEAR

A farmer had two sons. The elder was clever and knew his way around, but the younger one was stupid and good for nothing. When people saw him they said: 'That boy will give his father trouble.' It was always the elder boy who had to help his father; but if he was sent on an errand late at night and on the way he had to cross the churchyard or some other dismal place, he would plead: 'No father, I'd rather not go, it makes me shudder.'

When the younger brother sat in a corner and heard people telling ghost stories by the fire, he couldn't understand them when they said: 'Oh, that makes me shudder!' 'Why do they always say it makes me shudder, it makes me shudder,' he asked himself, 'I can't shudder – that must be something I have to learn.'

One day his father spoke to him: 'Listen my boy, you're getting older. It's about time you started to work. Look at your brother, he earns his keep; but what do you have to offer?' 'Father, I'd like to learn something,' he answered, 'if I had my choice I'd learn to shudder; I don't know the first thing about it.' His brother grinned and thought: 'Heavens, what a fool he is! He'll never get anywhere.' The father sighed: 'You'll learn soon enough what it is to be afraid; but you won't earn a living that way.'

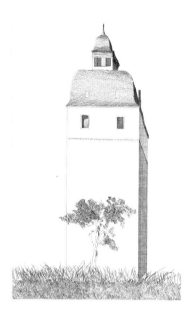

A few days later the father was telling the sexton his problems: 'The boy's so stupid; he won't work and can't grasp the simplest thing. Just think, when I asked him what he wanted to do, he said he was going to learn to shudder.' 'If that's all he wants,' the sexton grinned, 'I'll teach him. Leave it to me; I'll straighten him out.'

So he took the boy on and gave him the job of bell-ringer. Some days later he woke him at midnight and told him to go to the church to ring the bell. 'I'll teach him what fear is,' he thought, as he took a short cut to the tower. As the boy was about to ring the bell, he turned and saw a white shape on the stairs. 'Who's there?' he called, but the figure was silent. 'Speak up or get out. What do you want here anyway?' Expecting the boy to take him

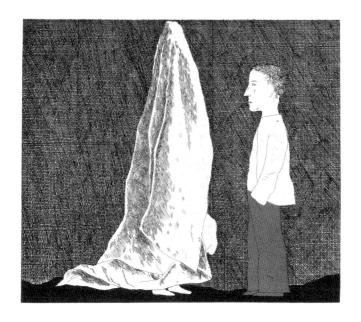

for a ghost, the sexton didn't move. So the boy shouted again: 'What do you want here? Answer me, or I'll throw you down the stairs!' But the sexton didn't take the threat seriously and stood perfectly still. The boy gave him one more chance but when he got no answer he jumped on the startled ghost and kicked him down the stairs. Then he rang the bell and went home to bed.

The sexton's wife waited patiently for her husband. After a few hours she began to worry, so she woke the boy and asked him: 'Do you know where my husband could be? He left for the church before you.' 'I don't know,' he replied, 'but a figure in white was standing at the top of the stairs, and since he wouldn't answer me or get out of my way, I took him for a rogue and threw him to the

bottom. Go and see if it's your husband, I'd be very sorry if it was. That would be bad luck.' The woman rushed to the tower and found the sexton moaning in a corner with a broken leg.

She carried him back to the house and ran screaming to the boy's father: 'Your son has kicked my husband down the stairs and broken his leg! Get him out of our house immediately!' The father was horrified and went to get the boy: 'Damn you!' he cursed. 'What mad tricks have you been up to? Are you completely off your head?' 'Listen to me father,' he answered, 'I've done nothing wrong. It was midnight; a figure was standing there and he looked as if he were up to no good! I didn't know who it was and asked him three times either to speak up or be off.' 'Oh! my God,' his father groaned, 'you bring me nothing but trouble. Get out of my sight.' 'Well father, I don't mind. Just let me stay until morning, then I'll go off and learn to shudder. At least that way I can earn some money.' 'Do whatever you want, I don't care. I'll give you ten pennies, then go away, the further the better. Don't tell anyone where you're from or mention my name. I'm ashamed of you.' 'Whatever you wish, father – if that's all you ask it's easy enough.'

At dawn the boy took his money and walked down to the highway, mumbling to himself: 'If only I could learn to shudder.' He passed a man who heard him talking. They walked together for a while, and when they came to a gallows, the fellow said: 'Look, this is the tree where

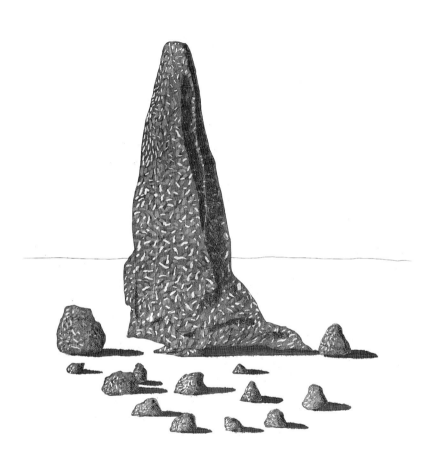

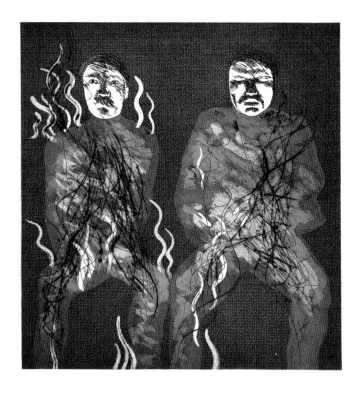

seven men married the ropemaker's daughter; now
they're learning to fly. Just stay right here and wait until
nightfall, then you'll learn to shudder.' 'That's no problem,'
the boy answered, 'if it's as easy as that I'll give you every
penny I have. Come back tomorrow morning.'

 The boy sat down by the gallows. When night fell
he lit a fire, but around midnight he began to feel cold.
A strong wind was blowing and the corpses bounced
against one another as they swung back and forth. The
boy looked up at them and thought: 'If I'm cold down here
by the fire, they must really be freezing up there.' He

was sorry for them so he climbed up a ladder, cut them down one by one, and propped them up around the roaring fire so they could warm themselves. They sat very still, and when their clothes caught fire he shouted: 'Be careful, or I'll hang you up again.' But the dead men heard nothing and their rags burned. The boy became angry and shouted louder: 'If you don't care, why should I help you. I don't want to catch fire myself,' and one after the other he hung them up again. Then he lay down by the fire and fell asleep.

In the morning the man returned to collect his money. 'Well boy, you must know by now what it's like to shudder?' 'What do you mean, shudder? Those fellows up there wouldn't say a word and were stupid enough to let their dirty rags get burned.' At this the man knew he wasn't going to be richer that morning, so he walked away muttering to himself: 'It beats me, I've never met anybody like him before.'

As the boy went off in the other direction he sighed: 'If only I could learn to shudder!' A shepherd overheard him and asked: 'What's your name?' 'I don't know.' 'Who is your father?' 'I'm not supposed to say.' 'And what are you grumbling about?' 'Well,' answered the boy, 'I wish I could learn to shudder. But no one can show me how it's done.' 'Nonsense,' the shepherd laughed, 'come along with me. I'll find a job for you.' So the boy joined him. In the evening they came to an inn where they decided to spend the night, and as they entered the bar the boy

mumbled again: 'If only I could learn to shudder.' The
innkeeper heard him and winked: 'If that's what you want,
I can help you out.' But his wife overheard him; 'Shut up!'
she said. 'For the job you're thinking of, quite a few young
men have paid with their lives. It would be a crime if such
lovely eyes as his were closed for good.' But the boy
interrupted her: 'I don't care how hard it is – I left home
to learn to shudder and that's what I'm here for.' And
he went on pleading until they told him the story.

'Not far from here is a haunted castle where great
treasures are hidden; enough, people say, to make a poor
man rich for life; but they are guarded by monsters and
evil spirits. The King has promised his daughter to the first
man who can spend three whole nights there; and it's worth
the risk as the Princess is the most beautiful girl in the
world. Many have gone in, but none has come out alive.'

The next morning, the boy went to see the King
and asked him if he could spend three nights in the castle.
The King liked his looks, so he offered him a choice
of any three objects to take with him. The boy chose
a fire, a lathe, and a carpenter's bench with its knife;
and the King had them taken there before nightfall.

When it was dark the boy went up to the castle and
built a huge fire in one of the rooms. He sat down on the
lathe and put the carpenter's bench by the fire. 'If only
I could learn to shudder,' he thought, 'but surely I'm
wasting my time here.' At around midnight he stirred
up the fire, and while he was blowing on the coals a wild

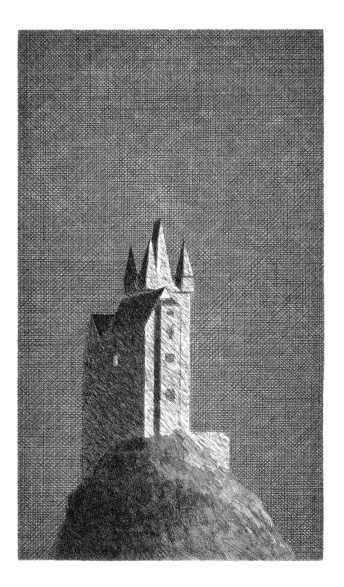

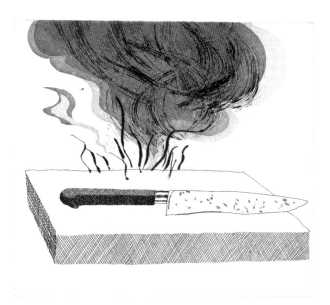

cry came up from the corner of the room. 'Aaowmeeow!
We're freezing!' 'You fools, what are you complaining
about? If you're cold, come and sit by me.' Two great black
cats leaped out of the darkness, and sitting down on each
side of the lathe glowered at him savagely with their fiery
eyes. When they had warmed themselves they sneered:
'Now friend, how about a game of cards?' 'Why not!'
he murmured, 'but let me see your paws first.' They
stretched out their legs and he saw their long sharp claws.
Then he caught them by the throat, lifted them on to the

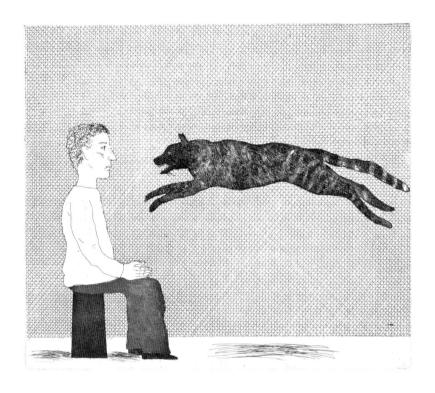

carpenter's bench and clamped their paws in the vice.
'I know your game,' he laughed, 'it's no fun playing cards
with you!' So he beat them to death and threw them out
into the moat.

 After silencing those two, he lay down to rest.
Suddenly out of every corner there rushed wild cats and
dogs on red-hot chains, screeching and stamping on his
fire. For a while he let them do as they pleased, but when
they began to get on his nerves he cried: 'Get out of here
you monsters!' and grabbing his knife he struck at them.

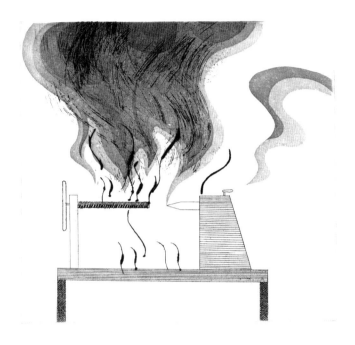

A few escaped, but most ended up dead in the moat.
The boy lay down again by the fire and fell asleep.

In the morning the King came, and when he saw the
boy lying on the floor he thought the ghosts had killed
him. 'It's a shame such a fine boy should be dead!' Hearing
that, the boy jumped up and laughed, 'It hasn't come to
that yet. One night is over, and the others will pass quickly
enough.' The King was amazed and so was the innkeeper
who couldn't believe his eyes. 'I didn't expect to see you
again. Now do you know what it's like to shudder?' 'No,
it's just a waste of my time,' the boy complained, 'if only
someone could teach me!'

On the second night he walked up to the old castle, sat down beside the fire and sang the same old song: 'If only I could learn to shudder!' At ten o'clock he heard a long piercing cry. It grew louder and wilder, then stopped abruptly and all was quiet – until suddenly half a man fell down the chimney. 'Hey, are you real? Where's your other half?' The shrieking started again and moments later the other half dropped at his feet.

'Wait a minute, I'll get a good fire going for you.' When the flames were high, he turned and saw that the two halves had joined together to make a giant figure sitting on his bench. 'That's not part of the bargain,' the boy shouted, 'that's my bench.' He struggled with the giant and threw him to the ground; but as they wrestled in a corner they fell on nine thigh bones and two skulls, so the boy challenged the monster to a game of skittles. He took the skulls, put them in the lathe and turned them till they were round. 'Now we'll have some fun,' he laughed. They played until the clock struck twelve and then the giant vanished. The boy lay down by the fire and fell asleep.

On the third night he returned to his bench. Towards midnight six giants walked in carrying a coffin. 'This must be my little cousin', he thought, 'who died just a few days ago.' When they put the coffin down, he lifted the lid. There was a dead man inside, his face as cold as ice; so he lifted the body out and sitting down by the fire, laid him in his lap. He rubbed the corpse to get the blood

45

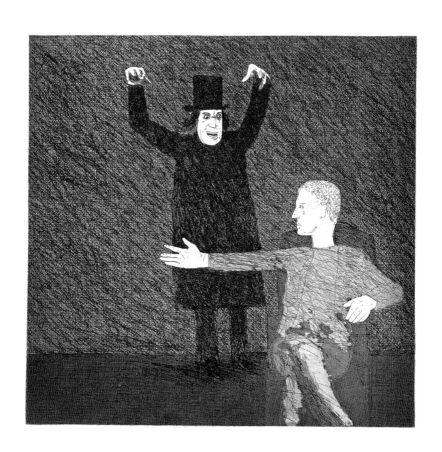

circulating, but it didn't help, so he put the body into his
bed, got a blanket and lay down beside it; after a while
the corpse warmed up and began to move. The boy was
delighted and whispered to him: 'See what I've done for
you, little cousin!' But the dead man put his hands round
the boy's neck and tried to strangle him. 'Is that how you
thank me?' he shouted, 'away with you'; and grabbing the
body he threw it into the box and slammed down the lid.
The six giants lifted the coffin on to their shoulders and
carried it away.

Soon after the wall began to shake and split apart,
and in the smoke there appeared a magnificent old giant
with a long white beard. 'Boy,' he thundered, 'you'll soon
know what it's like to shudder. You're going to die!' 'We'll
see who's going to die,' the boy answered. 'Yes, we'll see,'
the giant sneered, 'if you're the stronger I'll let you go.'
He led the way through a dark tunnel to a blacksmith's
forge, where he took an axe and with two blows drove
an anvil deep into the ground. 'That's nothing,' grinned
the boy walking over with him to another anvil. He split
it with a single blow, catching the monster's beard in the
crack. 'Now I have you,' he laughed, 'it's your turn to die.'
With an iron bar he thrashed the giant until he begged
and pleaded with him to stop, promising him a great
reward; so the boy set him free. They returned to the
castle, where the giant unlocked a cellar door and showed
him three chests of gold: 'One is for the poor, the second
for the King, and the third is yours.' Just then the clock

struck twelve and the giant vanished leaving the boy in total darkness. Next morning the King came and asked what had happened. 'My dead cousin came to see me and an old bearded fellow showed me three treasure chests in the cellar; but no one taught me to shudder.' The King was overjoyed: 'You have saved the castle,' he cried, 'now you may marry my daughter.'

The young Prince loved his wife but he still complained: 'If only I could learn to shudder!' At last the Princess's maid had an idea: she went out to a stream and caught a bucketful of fish. When the Prince was asleep she pulled his blankets back and poured the cold water with the little fish into his bed so that they squirmed and flopped all around him. The Prince sprang up: 'My God,' he cried, 'why do I shudder so?'

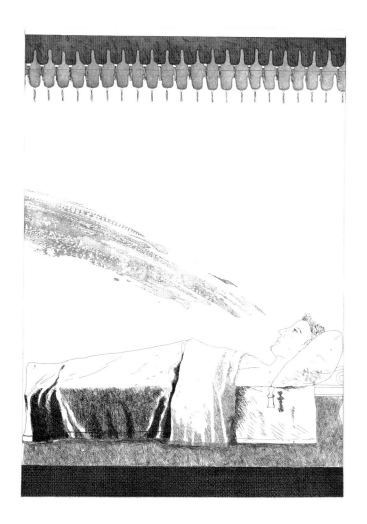

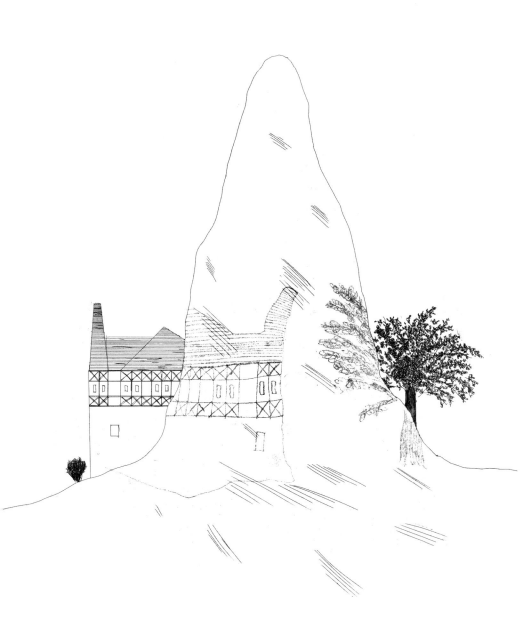

OLD RINKRANK

A King built a glass mountain and announced he would
give his daughter to the first man who could climb it
without falling. When a handsome boy fell in love with
the Princess, and went to the palace begging to marry her,
the King said: 'If you can climb the mountain, she will
be yours.' Overhearing this, the Princess thought: 'I will
go with him, then if he slips I'll be able to help him.'
So they went off together and began to climb.

Half-way up, it was the Princess who slipped and
fell; and at that moment the mountain opened and she
vanished. The boy made his way back sadly to the palace
where he told her father of the terrible accident. The King,
fearing his daughter was lost for ever, sent his men
to break into the mountain, but no one could find the
spot where she had disappeared.

The Princess had fallen deep down into a cave where
an old man with a long grey beard was waiting for her;
he caught her by the throat and threatened her with
a long sharp knife until she promised to cook his dinner,
make his bed, and do any other jobs he had for her. Every
morning the old man took a ladder out of his pocket,
climbed to the top of the mountain and drew it up after
him; and at night, when he came home, his pockets
were full of gold and silver.

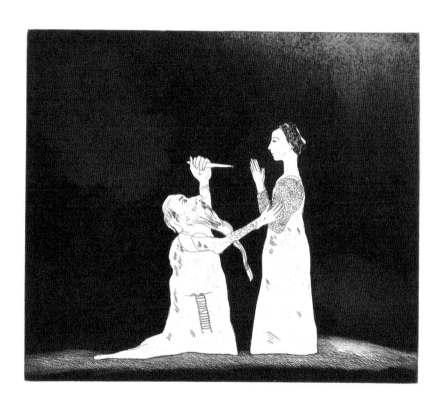

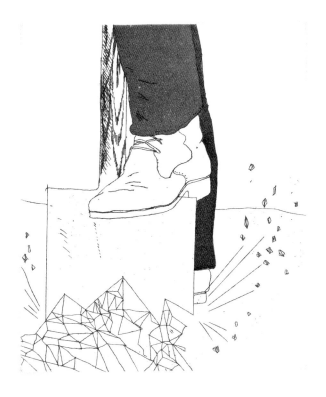

After many years she called him Old Rinkrank; and since she too had grown old, he called her Mother Mansrot. One day when he was out she made his bed, then she locked all the doors and windows except for a tiny one through which a little light was shining. When Old Rinkrank came home at dusk he knocked on the door and shouted: 'Mother Mansrot, open the door!' 'No, I won't,' she replied. He shouted again:

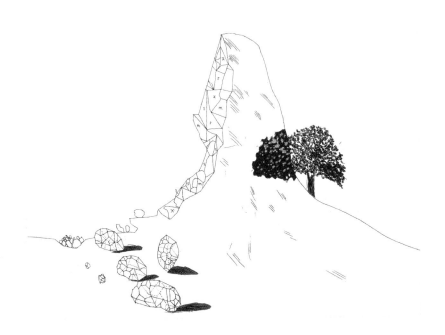

> It's me poor Old Rinkrank
> On my seventeen-foot legs
> On my one great swollen foot
> Mother Mansrot do the dishes.

'I've done the dishes,' she replied. So Old Rinkrank shouted again:

> It's me poor Old Rinkrank
> On my seventeen-foot legs
> On my one great swollen foot
> Mother Mansrot make my bed.

'I've made your bed,' she replied. So Old Rinkrank shouted again:

> It's me poor Old Rinkrank
> On my seventeen-foot legs
> On my one great swollen foot
> Mother Mansrot open the door.

Then he ran round the house to the little window. 'I'll see what she's up to,' he grumbled to himself. He peered in but his beard was so long that it got in the way, so he stuffed it through the opening and pushed his head in after. Then Mother Mansrot slammed down the window!

He screamed and howled and begged her to set him free; but now he had to do as she wanted. To escape she

55

needed the ladder, so she unlocked the door and took it from his pocket; then she tied a long ribbon to the window, and in no time climbed to the top of the mountain. From there she pulled on the ribbon and set the old man free.

When she reached the palace, she told her father and the boy about her years away from home and of the strange old man with the long grey beard. This time the King went with his men and they broke open the glass mountain and dug down until they found Old Rinkrank in his house; but of the gold and silver there was no trace.

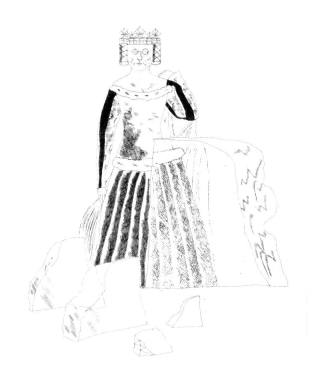

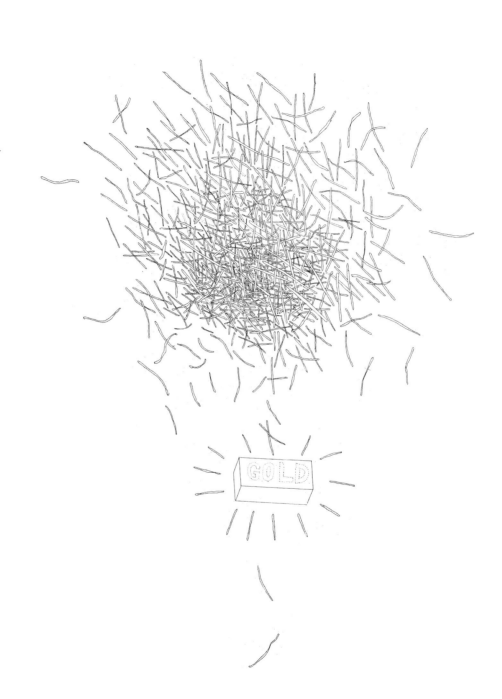

RUMPELSTILZCHEN

A poor miller happened to meet the King, and hoping to interest him he boasted: 'I have a beautiful daughter who can spin straw into gold.' The King was impressed: 'That's an art I like; if your daughter is really as clever as you say, bring her to my palace tomorrow and I'll see for myself what she can do.' So when the girl came the next day, the King took her to a small room filled with straw, gave her a spinning wheel and ordered her to get to work. 'You have one night to spin the straw into gold, but if you fail your head will be cut off.' Then he left the room and locked the door behind him.

The miller's daughter had no idea what to do; and after a while she saw there was no escape and burst into tears. But suddenly the door flew open and a strange little man rushed in: 'Good evening my dear, may I ask why you are crying?' 'I have to spin this straw into gold,' the girl sobbed, 'and I don't know how.' 'What will you give me if I do it for you?' asked the little man. 'My necklace,' she answered. He took the necklace, sat down at the wheel and with three turns filled a bobbin with gold; then he took a second bobbin and with three more turns filled that one too. He worked the whole night, and before morning all the straw had been spun into gold.

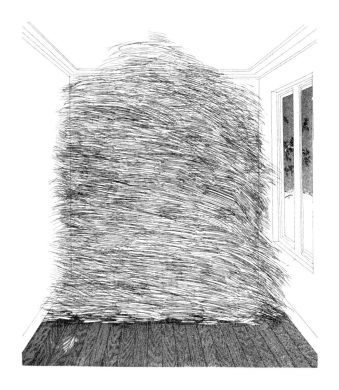

When the King returned at sunrise he was amazed
to see what she had done, so that night he locked her up
in a bigger room piled high with straw and set her to work
a second time. As the poor girl wept the door flew open
and in danced the little man. 'What will you give me if
I help you again?' 'I have only the ring on my finger,' she
replied. He took the ring and by morning he had spun
all the straw into shining gold.

When the King saw the gold he was pleased; but
being very greedy he had the biggest hall in the palace
filled with straw to the ceiling. As he slammed the door

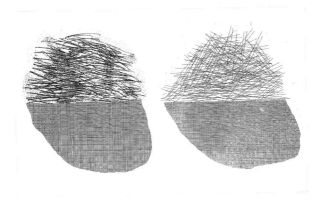

on the girl he made her a promise: 'If you can spin as much as this into gold in one night, I will marry you.' 'She is only a miller's daughter,' he thought, 'but in the whole world I will never find a richer wife.'

As soon as she was alone, the strange little fellow appeared. 'What will you give me if I do your work for you this last time?' 'I have nothing left.' 'Then promise me your first child if you become Queen.' 'A lot can happen between now and then,' she thought, and in despair, she agreed. The little man set to work and when all was ready he vanished; and in the morning when the King found the room filled with gold, he married the miller's daughter and made her his Queen.

A year later she gave birth to a beautiful boy; but by that time she had quite forgotten the strange little man. When he arrived at the palace one day to claim the child,

61

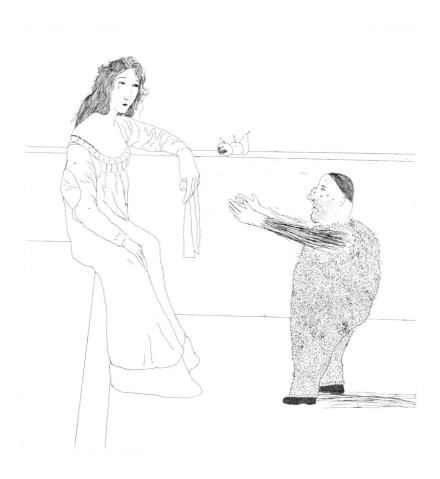

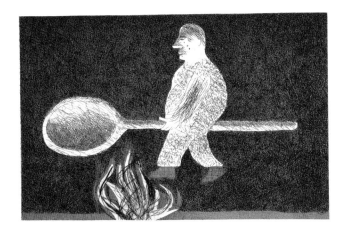

the Queen was terrified and offered him any part of the
kingdom if he would only leave her her son. But he
insisted: 'No, I prefer a living creature to all the treasures
in the world.' She wept so bitterly that at last he took pity
on her: 'If in three days you can guess my name I'll let you
keep your son.'

She thought all night of all the names she had ever
heard, and even sent out a messenger to comb the country
for more. When the little man came back the next morning,
she called him Caspar, Melchior, Balthasar, and every other
name she knew, but he kept repeating: 'That's not my name.'

The next day she went herself through the
neighbourhood questioning the people, and when the
little man came she listed the most unusual and curious

names she had heard: 'Maybe Ringo, or Zappa, or Kasmin?' But he always answered: 'That's not my name.' On the third night the messenger returned with a strange tale: 'I couldn't find a single new name, but below a high mountain at the edge of the forest, in the middle of nowhere, I saw a tiny house with a fire in front and a strange little man riding around on a cooking spoon. Every now and then he'd shout:

> Today I dance tomorrow I travel
> The Queen's child will soon be mine
> No one will know from where I came
> Or that RUMPELSTILZCHEN is my name.

The Queen was overjoyed to hear this news, for it came only just in time. Soon after the little man arrived and asked her: 'Tell me what is my name?'

'Is your name John?'

'No.'

'Is your name Paul?'

'No.'

'But maybe your name is … Rumpelstilzchen?'

The little man was furious and screamed: 'The devil told you that! The devil! The devil!' In his anger he stamped his foot so hard on the ground that his right leg went in up to his thigh. Foaming with rage, he grabbed his left foot with both hands and tore himself in two.

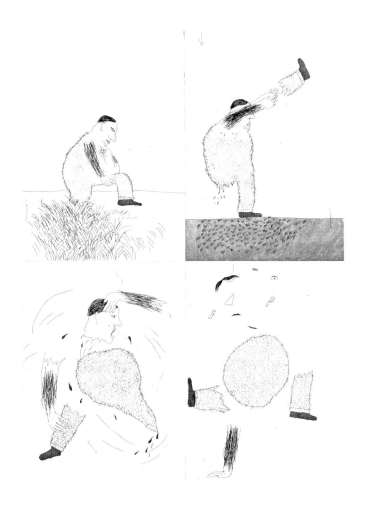

THE PLATES

The dimensions are taken from the final state proofs.

FRONTISPIECE

THE LITTLE SEA HARE